Fred Sandback Drawings 1968-2000

Annemarie Verna Gallery Zürich 2005

Published on the occasion of the exhibition
Fred Sandback Drawings 1968 – 2000

April 23 – June 25, 2005

With thanks to Amy Baker Sandback

Annemarie Verna Gallery
Neptunstrasse 42
8032 Zürich, Switzerland
Tel +4144 2623820
Fax +4144 2623826
office@annemarie-verna.ch
www.annemarie-verna.ch

Photographs: Thomas Cugini and Lorenz Cugini, Zürich
Translation: Julia Thorson, Zürich
Printing: Heinrich Winterscheidt GmbH, Düsseldorf

Trade Edition
Richter Verlag Düsseldorf
ISBN 3-937572-33-3

Printed and bound in Germany

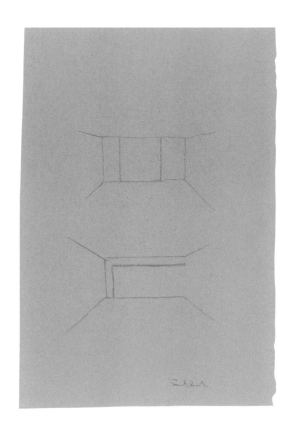

Untitled 1968
Pencil and pastel on paper
19 x 13 cm

Preface The artist legend handed down by Plinius with the famous Greek painters Apelles and Protogenes as its protagonists describes a contest between the two artists played out with a total of three fine lines. Arriving unannounced in the house of the absent Protogenes, Apelles draws a single line on the other's drawing board. Upon returning, Protogenes immediately recognizes the hand of his rival and outdoes the initial masterstroke with an even finer line. Yet Apelles does not admit defeat. In another color, he extends a third line all the way across between the two lines. The fact that the artists deem the thus created work as complete and worthy of keeping is one of the peculiar points of the anecdote. In our imagination, the story from antiquity leaves behind an abstract linear drawing that owes its existence in our mind to the prestige and potential of the line. The configuration as well as the character of the three lines is left open and indefinite, which is why this aspect of the story has been discussed time and again and interpreted anew throughout the ages.

"The line is a means to mediate the quality or timbre of a situation, and has a structure which is quick and abstract and more or less thinkable, but it's the tonality or if you want, wholeness of a situation that is what I'm trying to get at," noted Fred Sandback in 1986. Purism, unambiguity, geometry – all attributes that are connected with the idea of the line and link it with reductionistic stringency and narrowness – are manifestly rejected by an artist whose lifework can be identified as it were with the line. He is concerned with the ambivalence of the line, its ambiguity. A line can portray something or merely be the line itself, representing or presenting, generating illusions or doing away with them.

In his early endeavors as an artist, Fred Sandback came upon the line as a found material, as a real thing. Initially in the form of steel wire and rubber string and later as acrylic yarn. From the beginning, he understood his work as sculpture, but only as sculpture possessing neither volume nor mass and encompassing no interior. They are complex experiences that were given to him through and by means of his work and that should be accessible and approachable in a quite literal sense for those viewing the works. The sculptures are realized by the artist in concrete architectonic conditions, in existing spaces, whereby the spaces increasingly make up a substantial part of the sculptures.

Paper and pencil offer the significant and intelligent artist and draughtsman discrete visual possibilities. They necessitate representational forms that on one hand have to do with the work in the exhibition space, being closely related to it, and yet on the other exemplify the themes of the work in a more descriptive way. Our perception is oriented to lines, both those that are concealed and those that are visible. Lines depict space and construct perspective. The line likewise lends itself to the delineation of surfaces and bodies. Even scant constellations of lines possess the character of a sign. All these are objective findings that are of central importance for the sculptures as well as the drawings and graphic works by Fred Sandback.

The spatial and material reality of the built sculptures thus informs, as it were, the fictional representation with drawings and graphic works and directs their readability. Seldom are the drawings merely sketches or working drawings, which would have

been unsatisfactory considering Fred Sandback's genuine interest in his drawing work. The line drawing is for the most part placed in the center of the sheet of paper. The levels of the picture are ordered and weighted according to the significance of the picture elements. Often a fine isometric construction of a real existing space is initially laid out and put underneath. Unlike with Sandback's spatial works, the viewer stands outside the representation. He sees both inside and out and views the space as a three-dimensional plastic body. Into this view of space, the artist defines the sculpture with a colored pencil. The strongly drawn lines manifest themselves with clear ambiguity as both a projection of the sculpture and as an autonomous and self-certain sign. The illusionistic isometric spatial outline causes the sculpture to thus appear as a Vierge ouvrante-type cabinet figure. It proves itself as both a three-dimensional representation and as a planar constellation of lines. A step forward is taken by other sheets on which the solid strokes of colored chalk exist in a surmisable spatial relation to one another, deriving from this the stability and security of their positioning. A step back is then taken by the drawings of isometric representations of space that are freely worked with the pastel chalk.

The privilege of the line that so exclusively and successfully characterizes and distinguishes the drawings and the sculptures of Fred Sandback is not simply based on a specific preference and partiality of the artist. Rather, the line always has a clear connection to the space. Emptiness and fullness prove to be substantial polarities. His drawing and graphic work illustrates the tension between two-dimensional representation and the three-dimensional model, namely that of sculpture. The sculptures have extension and volume through the spaces in which they transpire. The woolen strings exhibit a slightly frayed quality that makes them appear as lines drawn through the space.

Gianfranco Verna

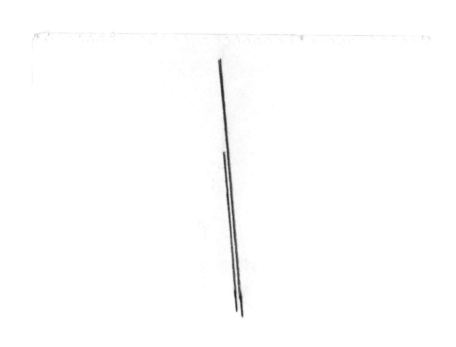

Untitled n.d.
Pastel pencil on paper
22,8 x 30,4 cm

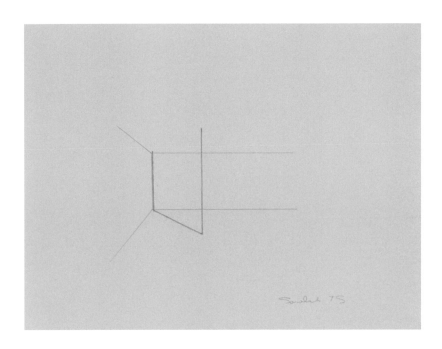

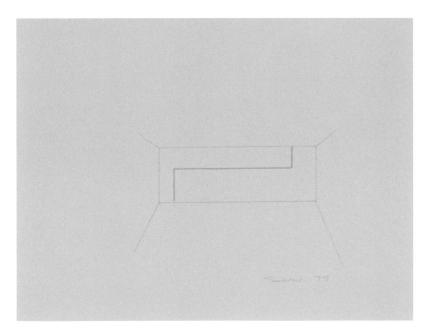

Untitled 1975
Pencil and pastel pencil on paper
21,5 x 27,8 cm

Untitled 1975
Pencil and pastel pencil on paper
23 x 30 cm

Untitled 1975
Pencil and carbon on paper
27,9 x 35,5 cm

Untitled 1975
Pencil and red conté on paper
27,9 x 35,5 cm

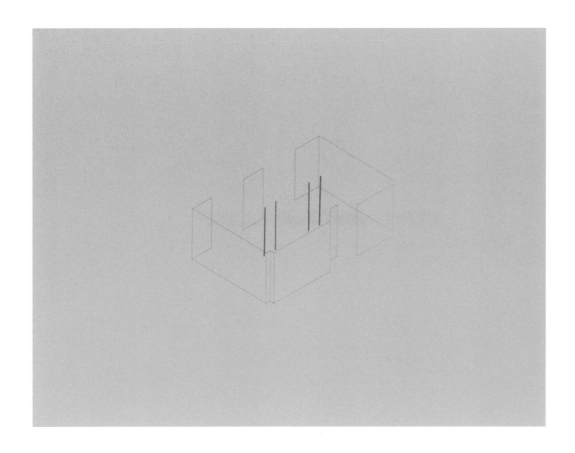

Untitled 1981
Installation Annemarie Verna Gallery
Pencil and pastel pencil on paper
50 x 65 cm

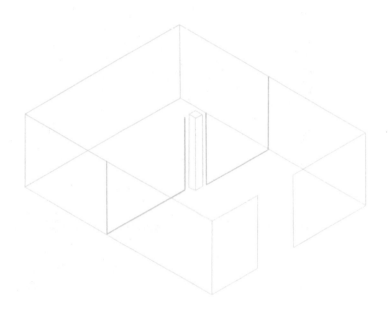

Untitled 1985
Pencil and pastel on paper
57,2 x 76,2 cm

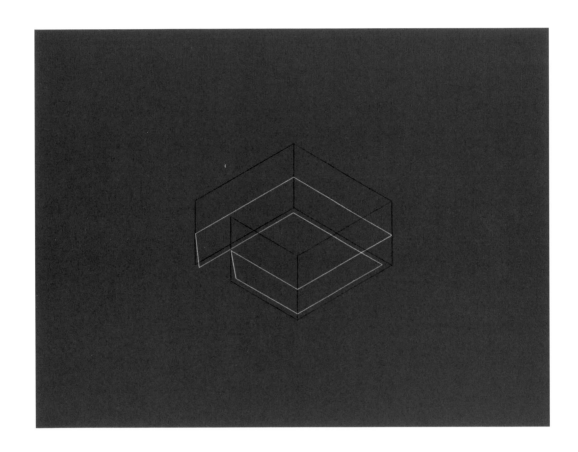

Untitled 1985
White ink and black pencil on blue paper
50 x 65 cm

Untitled 1985
Installation Fred Sandback Museum
Pastel pencil and pencil on paper
96,5 x 127 cm

Untitled 1985
Installation Fred Sandback Museum
Pastel pencil and pencil on paper
96,5 x 127 cm

Installation Fred Sandback Museum
Pastel pencil and pencil on paper
96,5 x 127 cm

Installation Fred Sandback Museum
Pastel pencil and pencil on paper
96,5 x 127 cm

Installation Fred Sandback Museum
Pastel pencil and pencil on paper
96,5 x 127 cm

Untitled 1986
Gouache and pencil on paper
56,5 x 76 cm

Untitled 1987
Watercolor on paper
114,9 x 94,6 cm

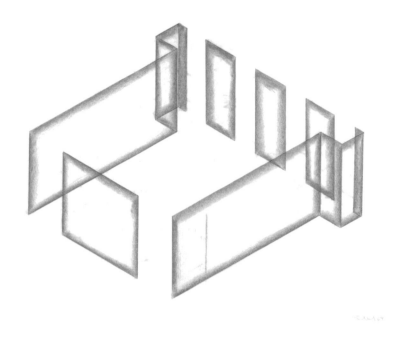

Untitled 1989
Pencil and pastel on paper
57 x 76 cm

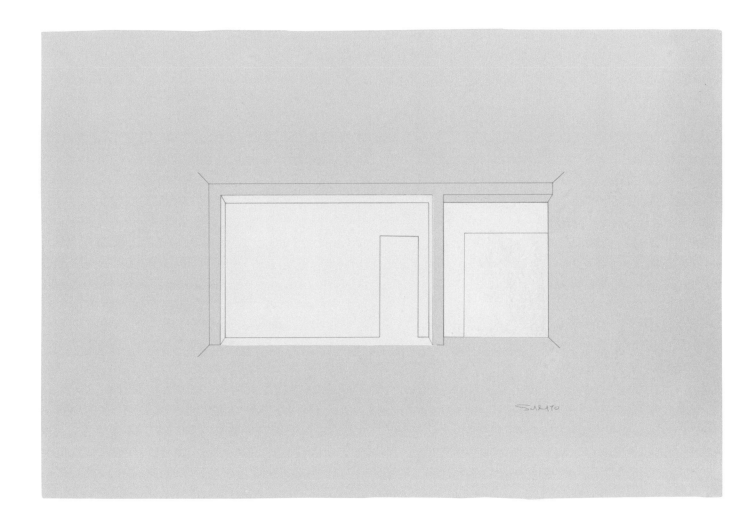

Untitled 1990
Pencil and pastel on lightgrey paper
76 x 110 cm

Untitled 1990
Pastel on paper
76,2 x 111,8 cm

Untitled 1990
Pastel on paper
76,2 x 111,8 cm

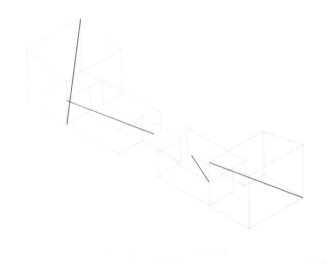

The First of 256 Constructions of Four Diagonal Lines
1970/2000
Pencil and black ink on paper
43 x 55.8 cm

The First of Four Thousand and
Ninety Six Constructions
of Four Diagonal Lines with Two Colors 1999
Pencil and colored pencil on paper
43 x 55.8 cm

The Second of Four Thousand and
Ninety Six Constructions
of Four Diagonal Lines with Two Colors 1999
Pencil and colored pencil on paper
43 x 55.8 cm

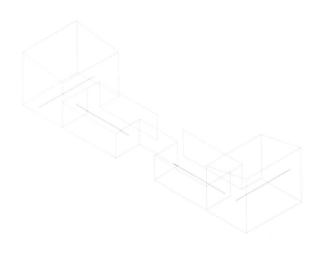

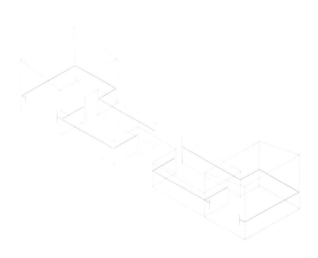

Construction of Four Horizontal Lines 1969/1999
Pencil and colored pencil on paper
43 x 55,8 cm

<div align="right">

Untitled 1999
Pencil and colored pencil on paper
43 x 55,8 cm

</div>

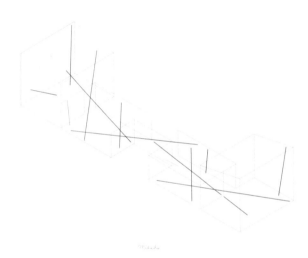

Mikado 2000
Pencil an black ink on paper
43 x 55,8 cm

Vorwort Eine von Plinius überlieferte Künstlerlegende, deren Protagonisten die berühmten griechischen Maler Apelles und Protogenes sind, schildert einen Wettstreit zwischen den beiden Künstlern anhand von genaugenommen insgesamt drei feinen Linien. Apelles, unangemeldeter Besucher im Haus des abwesenden Protogenes, zeichnet eine einzige Linie auf dessen Maltafel. Zurückgekehrt erkennt dieser sofort die Hand des Konkurrenten und überbietet seine Meisterschaft mit einer feineren Linie. Apelles gibt sich aber nicht geschlagen. In einer anderen Farbe zieht er eine dritte Linie der ganzen Länge nach zwischen die beiden Linien. Dass die Künstler das so entstandene Werk als gültig und aufbewahrungswürdig erachten, ist eine besondere Pointe der Anekdote. In unserer Imagination hinterlässt die Erzählung aus dem Altertum eine abstrakte, lineare Zeichnung, die ihre mentale Existenz dem Prestige und Potenzial der Linie verdankt. Die Konfiguration ebenso wie die Beschaffenheit der drei Linien bleibt offen und unbestimmt. Weshalb dieser Aspekt der Geschichte dann auch immer wieder diskutiert und jeweils zeitgemäss interpretiert wurde.

»Mit der Linie lässt sich die Qualität oder die Klangfarbe einer Situation vermitteln, und sie hat eine Struktur, die schnell und abstrakt und mehr oder weniger vorstellbar ist, aber es ist die Tonalität oder, wenn man so will, die Ganzheit einer Situation, der ich nahe kommen möchte.« Fred Sandback hat diese Beobachtung 1986 notiert. Purismus, Eindeutigkeit, Geometrie, alles Attribute, die der Idee der Linie offenbar anhaften und sie mit reduktionistischer Strenge und Begrenztheit in Verbindung bringt, werden von ihm ausgeschlagen. Ausgerechnet von einem Künstler, dessen Lebenswerk sich sozusagen mit der Linie identifizieren lässt. Ihn beschäftigt die Ambivalenz der Linie, ihre Vieldeutigkeit. Eine Linie stellt etwas dar, oder bloss sich selber, sie kann also repräsentieren oder präsentieren, eine Illusion erzeugen oder aufheben.

Bei seinen frühen künstlerischen Unternehmungen hat Fred Sandback die Linie als reales Ding vorgefunden und verwendet. Zunächst in Form von Stahldraht und Gummischnur und später als Acrylgarn. Von Anfang an versteht er seine Arbeiten als Skulpturen, aber Skulpturen, die weder Volumen noch Masse aufweisen und kein Inneres umfassen. Es sind komplexe Erfahrungen, die ihm durch und anhand seiner Arbeit zuteil werden und diese sollen auch dem Betrachter der Werke wortwörtlich zugänglich sein. Die Skulpturen werden vom Künstler in konkreten architektonischen Gegebenheiten, in bestehenden Räumen realisiert, wobei die Räume mehr und mehr einen wesentlichen Teil der Skulpturen ausmachen.

Papierbogen, Stift und Stichel offerieren dem bedeutenden und intelligenten Zeichner und Grafiker eigenständige bildnerische Möglichkeiten. Sie erfordern Darstellungsformen, die einerseits mit der Arbeit im Ausstellungsraum zu tun haben, ja eng damit verbunden sind, andererseits aber in mehr deskriptiver Weise die Werkthematik exemplifizieren.

Unsere Wahrnehmung orientiert sich an Linien, verborgenen und sichtbaren. Mit Linien wird Raum dargestellt, die Perspektive konstruiert. Ebenso eignet sich die Linie zur Abgrenzung von Flächen und Körpern. Schon knappe Linienkonstellatio-

nen besitzen Zeichencharakter. Alles objektive Befunde, die sowohl für die Skulpturen, wie für die Zeichnungen und Grafiken von Fred Sandback von zentraler Bedeutung sind.

So informiert die räumliche und materielle Wirklichkeit der gebauten Skulpturen gleichsam die fiktionale Darstellung bei Zeichnungen und Grafiken und steuert deren Lesbarkeit. Selten sind die Zeichnungen blosse Entwürfe oder Werkskizzen, was angesichts von Fred Sandback's genuinem Interesse an seinem zeichnerischen Oeuvre unbefriedigend gewesen wäre.

Die Strichzeichnung ist zumeist im Zentrum des Papierbogens plaziert. Die Bildebenen sind gemäss der Bedeutung der Bildelemente angeordnet und gewichtet. Oftmals ist zunächst eine feine isometrische Konstruktion eines real existierenden Raumes angelegt und unterlegt. Anders als bei Sandback's räumlichen Arbeiten befindet sich der Betrachter ausserhalb der Darstellung. Er überblickt sowohl innen wie aussen und sieht den Raum als plastischen Körper. In diese Raumansicht setzt der Künstler mit farbigem Stift die Skulptur. Die kräftiger gezogenen Linien manifestieren sich in klarer Zweideutigkeit sowohl als Projektion der Skulptur, wie als selbstständiges und selbstgewisses Zeichen. Der illusionistische isometrische Raumaufriss lässt so die Skulptur als Klappfigur erscheinen. Sie bewährt sich gleichermassen als dreidimensionale Darstellung und als plane Linienkonstellation. Einen Schritt weiter gehen andere Blätter, auf denen die festen, farbigen Kreidestriche in erahnbarer räumlicher Beziehung zueinander stehen und daraus die Stabilität und Sicherheit ihrer Positionierung ableiten. Einen Schritt zurück tun die Zeichnungen isometrischer Raumdarstellungen, die mit der Pastellkreide frei bearbeitet sind.

Das Privileg der Linie, das so ausschliesslich und erfolgreich die Zeichnungen und die Skulpturen von Fred Sandback kennzeichnet und auszeichnet, beruht nicht einfach auf einer eigentümlichen Präferenz und Voreingenommenheit des Künstlers. Vielmehr hat die Linie immer einen klaren Bezug zum Raum. Leere und Fülle erweisen sich als substanzielle Polaritäten. Das zeichnerische und grafische Werk veranschaulicht die Spannung zwischen der zweidimensionalen Repräsentation und dem dreidimensionalen Modell, nämlich der Skulptur. Die Skulpturen haben Ausdehnung und Volumen durch die Räumlichkeiten, in denen sie sich ereignen. Die Wollfäden besitzen eine leicht ausfasernde Qualität, die sie als in den Raum gezeichnete Linien erscheinen lassen.

Gianfranco Verna

© Thomas Cugini Zürich, 1991

Fred Sandback
1943 Bronxville, New York – 2003 New York, NY

Education
Williston Academy, Easthampton, MA 1957 – 61
Theodor Heuss Gymnasium, Heilbronn, Germany, 1961 – 62
Yale University, New Haven, CT, 1962 – 66
Yale School of Art and Architecture, 1966 – 69

Exhibitions Annemarie Verna Gallery Zürich
1971, 1972, 1976, 1978, 1981, 1986, 1988, 1991, 1996, 2000, 2003, 2005